Rivera

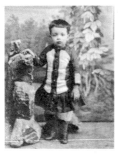

Diego Rivera at the age of three, c. 1889

In 1921 Diego Rivera returned home to Mexico, after fourteen years in Europe, where he had already built up a wide-ranging artistic oeuvre. Rivera, the son of schoolteachers, was born in Guanajuato in 1886 and trained as a painter at the art college in Mexico City. The subsequent apprentice years in Spain and his involvement with the Cubist avantgarde in France, together with his study of Renaissance frescoes in Italy, considerably enriched his style. The new cultural programme launched by the post-revolutionary Mexican government gave Rivera the opportunity to translate these experiences into monumental fresco cycles which he executed for public buildings. Alongside José Clemente Orozco and David Alvaro Siqueiros, he became one of the protagonists of the »Renaissance of Mexican mural painting«, and created a new iconography to represent the complex social and national themes which interwove socialist symbolism with religious motifs and a pre-Hispanic world view. Married to the painter Frida Kahlo, he also painted many oils and watercolours. Until his death in 1957, he was a provocative political activist who caused a stir not only in Mexico, but also in the USA and the Soviet Union.

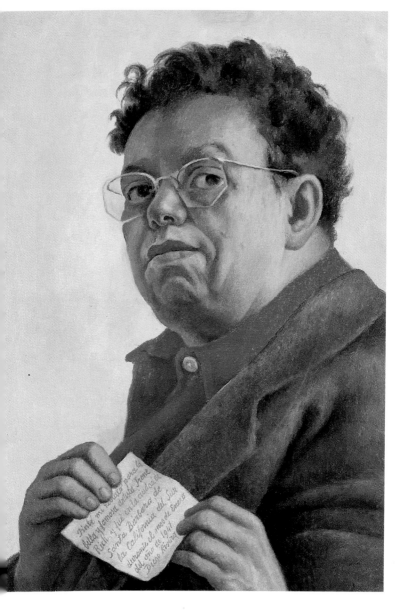

Diego Rivera: Self-portrait dedicated to Irene Rich, 1941
Selbstbildnis Irene Rich gewidmet · Autoportrait dédié à Irene Rich
Northampton, MS, Smith College Museum of Art, Gift of Irene Rich
Clifford, 1977
Also reproduced in *Diego Rivera*, Benedikt Taschen Verlag

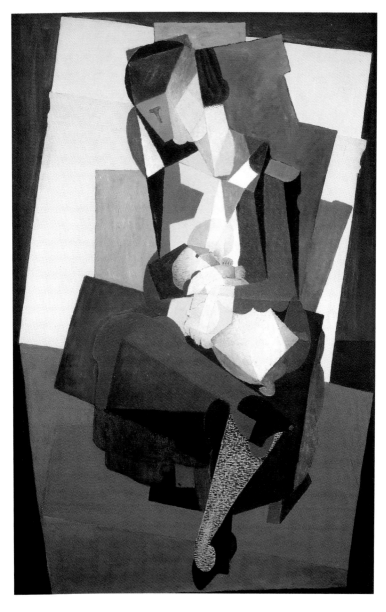

Diego Rivera: Motherhood – Angelina and the Child Diego, 1916
Mutterschaft – Angelina und das Kind Diego · Maternité – Angelina et
l'enfant Diego
Mexico City, Museo de Arte Alvar y Carmen T. de Carrillo Gil,
MCG – INBA, Photo: Rafael Doniz
Also reproduced in *Diego Rivera*, Benedikt Taschen Verlag

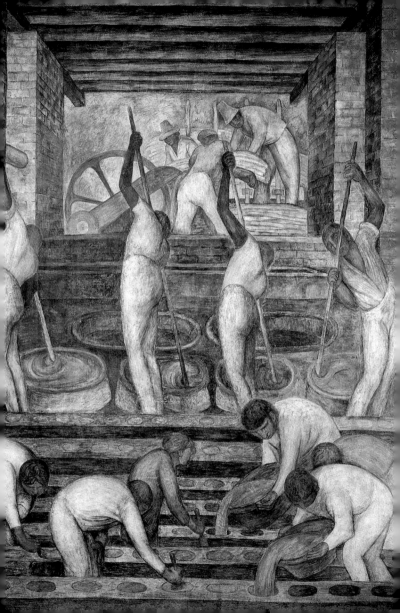

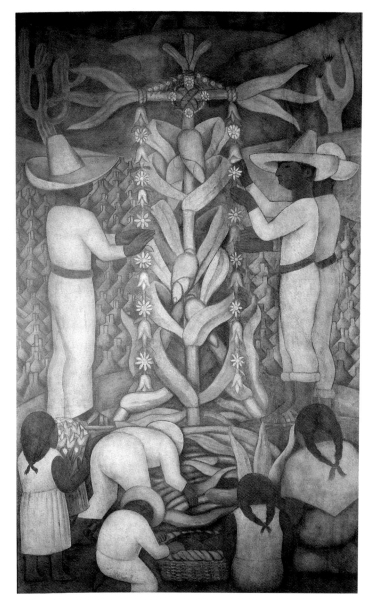

Diego Rivera: The Maize Festival, 1923–1924
Das Mais-Fest · La Fête du maïs
Mexico City, Secretaría de Educación Pública – SEP (from the cycle:
Political Vision of the Mexican People). Photo: Rafael Doniz
Also reproduced in *Diego Rivera*, Benedikt Taschen Verlag

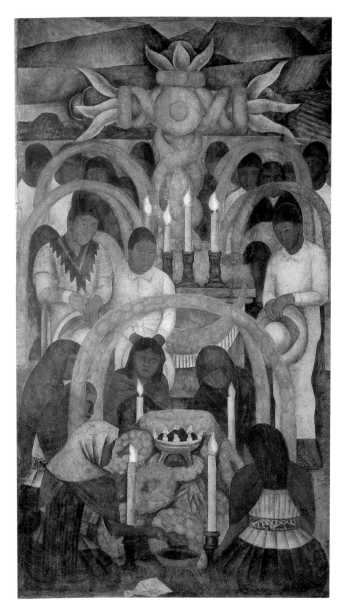

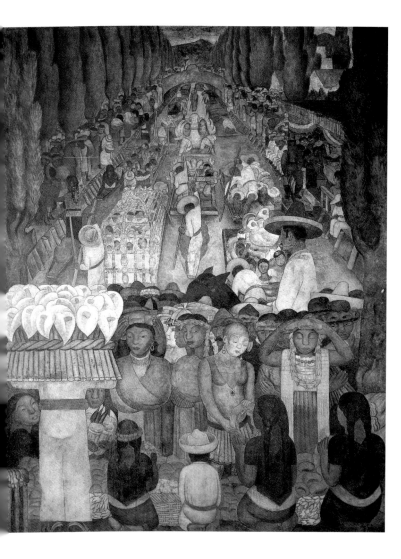

Diego Rivera: Good Friday on the Santa Anita Canal, 1923–1924
Karfreitag im Kanal von Santa Anita · Vendredi saint sur le canal
de Santa Anita
Mexico City, Secretaría de Educación Pública – SEP (from the cycle:
Political Vision of the Mexican People), Photo: Rafael Doniz
Also reproduced in *Diego Rivera*, Benedikt Taschen Verlag

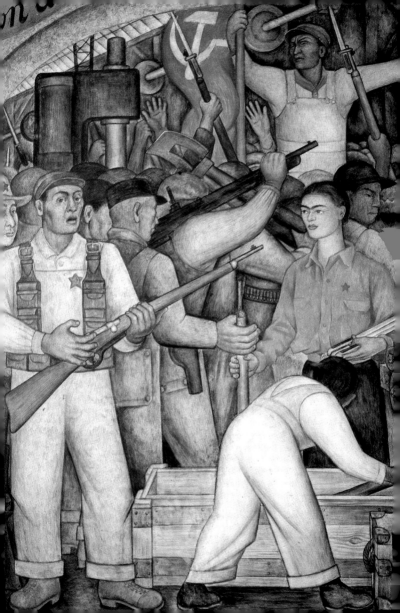

Diego Rivera: The Arsenal – Frida Kahlo Distributes Arms
(detail), 1928
Das Waffenarsenal – Frida Kahlo verteilt Waffen (Detail) · L'Arsenal
– Frida Kahlo distribuant des armes (détail)
Mexico City, Secretaría de Educación Pública – SEP (from the cycle:
Political Vision of the Mexican People), Photo: Rafael Doniz
Also reproduced in *Diego Rivera*, Benedikt Taschen Verlag

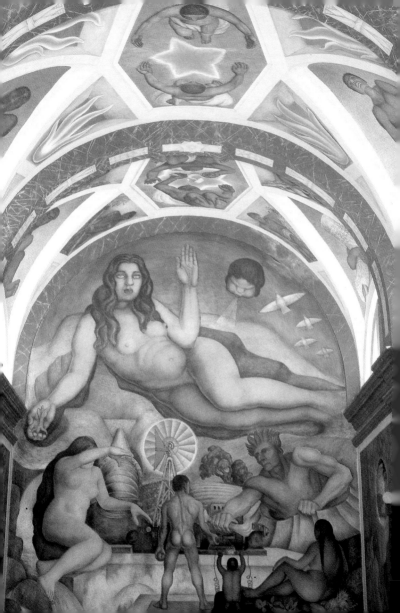

Diego Rivera: The Liberated Earth with the Powers of Nature
Controlled by Man, 1926–1927
Die befreite Erde mit den durch den Menschen kontrollierten
Naturkräften · La Terre libérée et les forces naturelles contrôlées
par l'homme
Chapingo, Universidad autónoma de Chapingo, Escuela Nacional de
Agricultura (from the cycle: Song to the Earth and to Those who Till
it and Liberate it), Photo: Rafael Doniz
Also reproduced in *Diego Rivera*, Benedikt Taschen Verlag

Diego Rivera: Germination, 1926–1927
Keimen · Germination
Chapingo, Universidad autónoma de Chapingo, Escuela Nacional de
Agricultura (from the cycle: Song to the Earth and to Those who Till it
and Liberate it – Natural Evolution), Photo: Rafael Doniz
Also reproduced in *Diego Rivera*, Benedikt Taschen Verlag

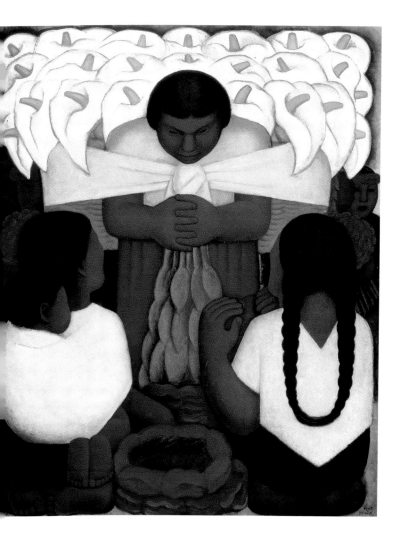

Diego Rivera: Flower Festival, 1925
Das Fest der Blumen · La Fête des fleurs
Los Angeles County Museum of Art, Los Angeles County Fund
25.7.1.
Also reproduced in *Diego Rivera*, Benedikt Taschen Verlag

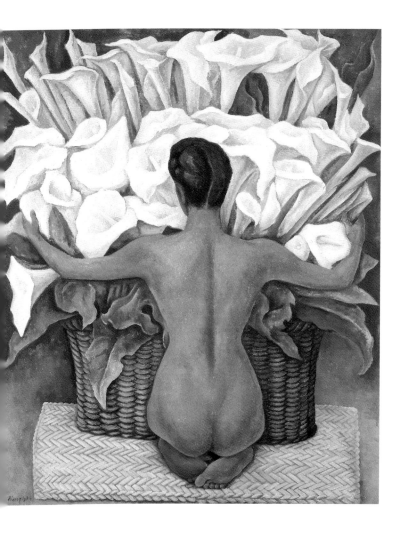

Diego Rivera: Nude with Calla Lilies, 1944
Akt mit Calla-Lilien · Nu aux arums
Mexico City, Collection Emilia Gussy de Gálvez, Photo: Rafael Doniz
Also reproduced in *Diego Rivera*, Benedikt Taschen Verlag

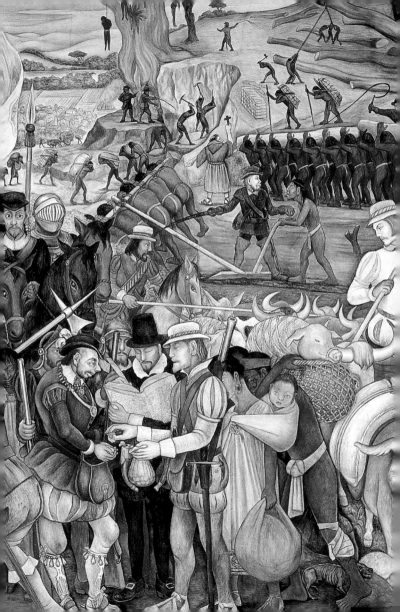

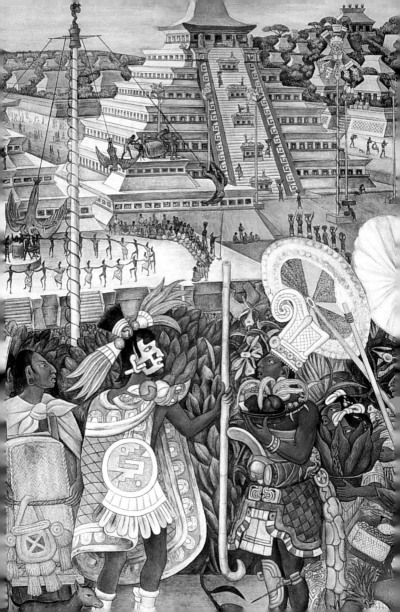

Diego Rivera: The Culture of Totonaken (detail), 1950
Die Kultur der Totonaken (Detail) · Culture Totonaque (détail)
Mexico City, Palacio Nacional (from the cycle: Pre-Hispanic and
Colonial Mexico), Photo: Rafael Doniz
Also reproduced in *Diego Rivera*, Benedikt Taschen Verlag

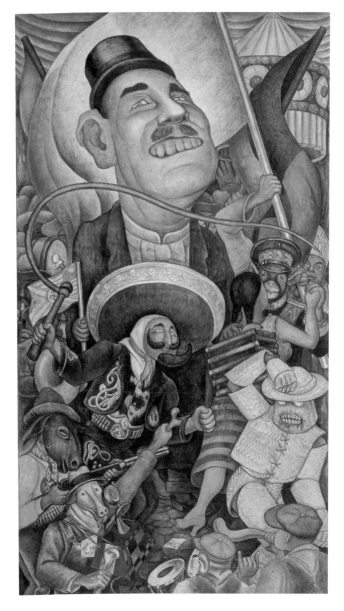

Diego Rivera: Dictatorship, 1936
Die Diktatur · La Dictature
Mexico City, Palacio de Bellas Artes (from the cycle: Carnival of
Mexican Life). Photo: Rafael Doniz
Also reproduced in *Diego Rivera*, Benedikt Taschen Verlag

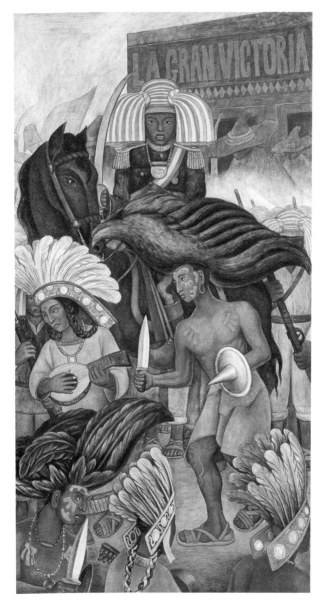

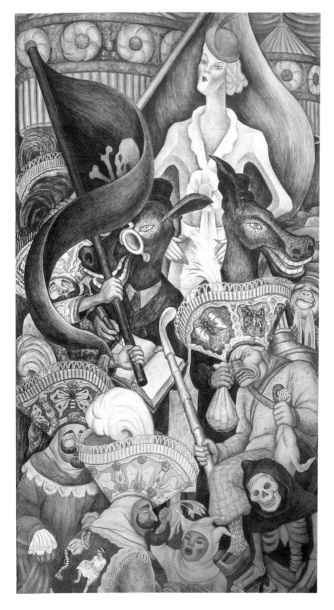

Diego Rivera: Folkloric and Touristic Mexico, 1936
Folkloristisches und touristisches Mexiko · Mexique folklorique
et touristique
Mexico City, Palacio de Bellas Artes (from the cycle: Carnival of
Mexican Life). Photo: Rafael Doniz
Also reproduced in *Diego Rivera*, Benedikt Taschen Verlag

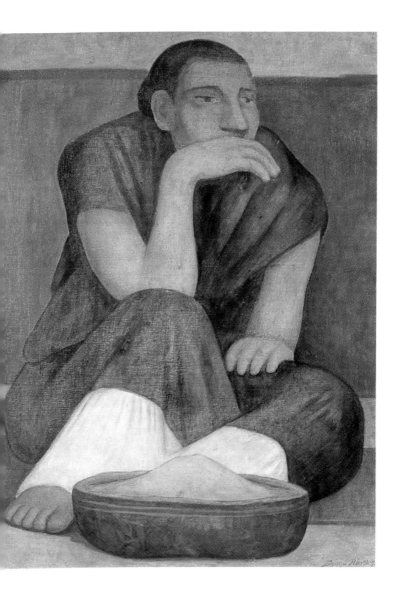

Diego Rivera: The Pinole Seller, 1936
Die Pinole-Verkäuferin · La Vendeuse de pinole
Mexico City, Museo Nacional de Arte, MUNAL – INBA,
Photo: Rafael Doniz
Also reproduced in *Diego Rivera*, Benedikt Taschen Verlag

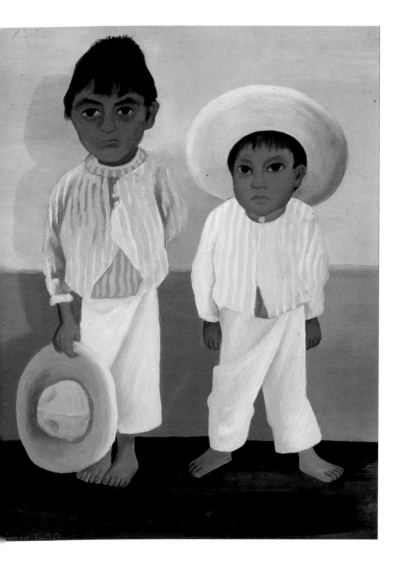

Diego Rivera: My Godfather's Sons (Portrait of Modesto and
Jesús Sánchez), 1930
Die Söhne meines Gevatters (Bildnis von Modesto und Jesús
Sánchez) · Les Fils de mon compère (Portrait de Modesto et
Jesús Sánchez)
Mexico City, Collection of Fomento Cultural Banamex,
Photo: Rafael Doniz
Also reproduced in *Diego Rivera*, Benedikt Taschen Verlag

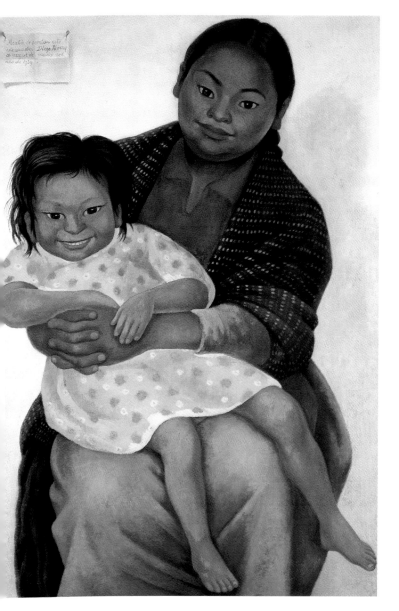

Diego Rivera: Portrait of Modesta and Inesita, 1939
Bildnis von Modesta und Inesita · Portrait de Modesta et Inesita
Mexico City, Collection of the Estate of Licio Lagos.
Photo: Rafael Doniz
Also reproduced in *Diego Rivera*, Benedikt Taschen Verlag

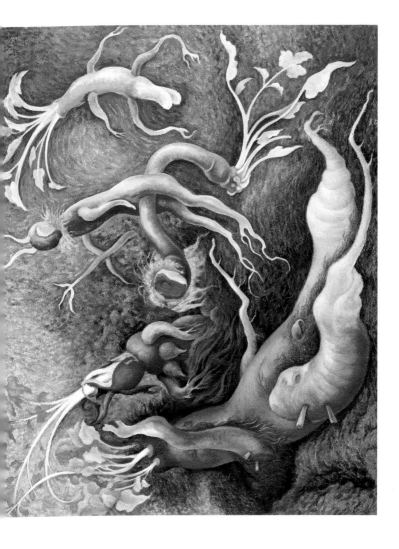

Diego Rivera: The Temptations of Saint Antony, 1947
Die Versuchungen des Heiligen Antonius · Les Tentations
de saint Antoine
Mexico City, Museo Nacional de Arte, MUNAL – INBA.
Photo: Rafael Doniz
Also reproduced in *Diego Rivera*, Benedikt Taschen Verlag

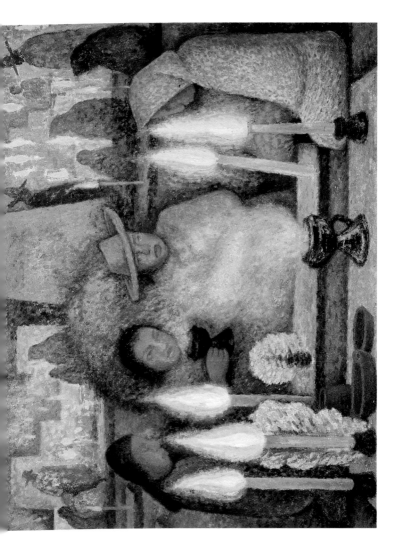

Diego Rivera: Day of the Dead, 1944
Tag der Toten · Jour des morts
Mexico City, Museo de Arte Moderno, MAM – INBA.
Photo: Rafael Doniz
Also reproduced in *Diego Rivera*, Benedikt Taschen Verlag

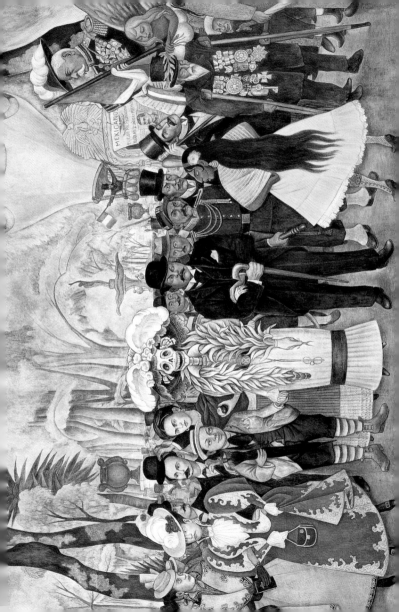

Diego Rivera: Dream of a Sunday Afternoon in Alameda Park (detail),
1947–1948
Traum eines Sonntagnachmittags im Alameda-Park (Detail) · Rêve
d'un dimanche après-midi dans le parc Alameda (détail)
Mexico City, Museo Mural Diego Rivera. Photo: Rafael Doniz
Also reproduced in *Diego Rivera*, Benedikt Taschen Verlag

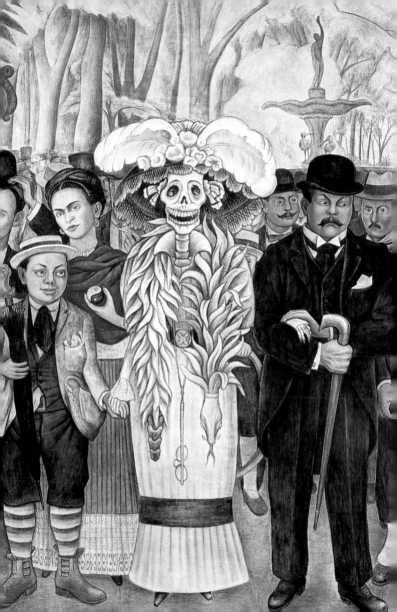

Diego Rivera: Dream of a Sunday Afternoon in Alameda Park (detail),
1947-1948
Traum eines Sonntagnachmittags im Alameda-Park (Detail) · Rêve
d'un dimanche après-midi dans le parc Alameda (détail)
Mexico City, Museo Mural Diego Rivera. Photo: Rafael Doniz
Also reproduced in *Diego Rivera*, Benedikt Taschen Verlag

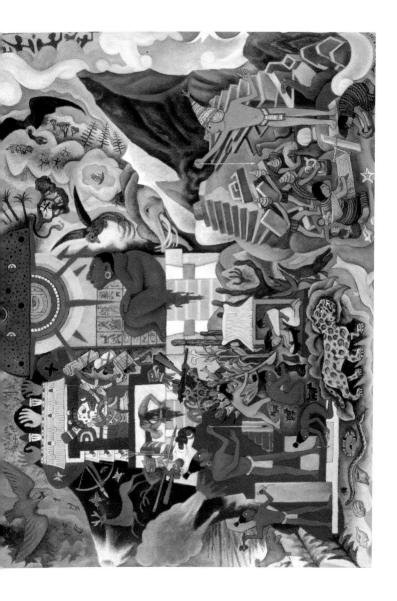

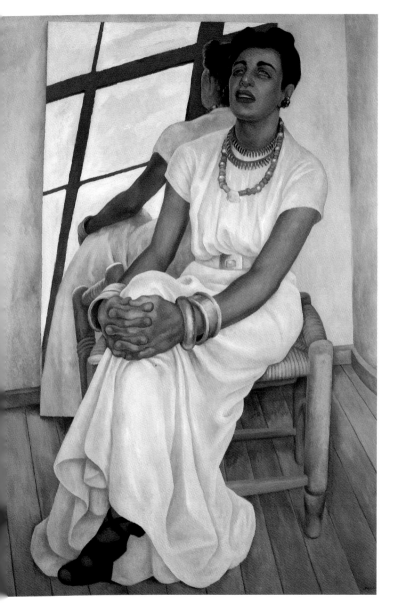

Diego Rivera: Portrait of Lupe Marín, 1938
Bildnis Lupe Marín · Portrait de Lupe Marín
Mexico City, Museo de Arte Moderno, MAM – INBA.
Photo: Rafael Doniz
Also reproduced in *Diego Rivera*, Benedikt Taschen Verlag

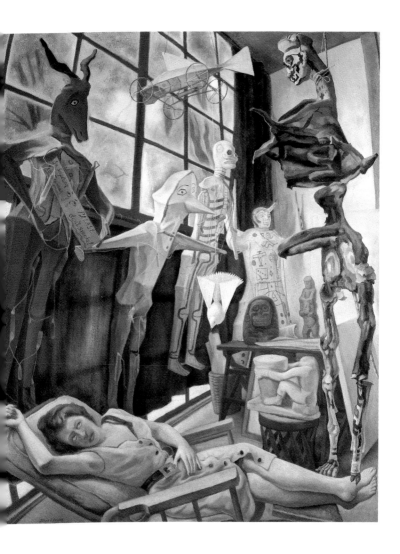

Diego Rivera: The Painter's Studio, 1954
Das Atelier des Malers · L'Atelier du peintre
Mexico City, Collection of Secretaría de Hacienda y Crédito Público.
Photo: Rafael Doniz
Also reproduced in *Diego Rivera*, Benedikt Taschen Verlag

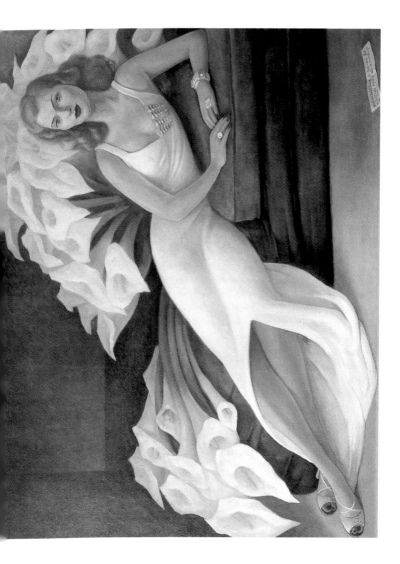

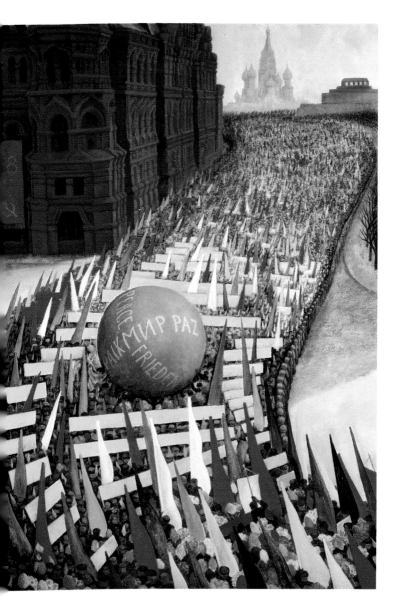

Diego Rivera: May Day Procession in Moscow, 1956
1.-Mai-Umzug in Moskau · Défilé du 1er Mai à Moscou
Mexico City, Collection of Fomento Cultural Banamex.
Photo: Rafael Doniz
Also reproduced in *Diego Rivera*, Benedikt Taschen Verlag